MW01493972

Islamic Art

in The Metropolitan Museum of Art

A WALKING GUIDE

Navina Najat Haidar and Kendra Weisbin

VALLEY RANCH
Irving Public Library System
Irving, Texas 75060

33163016749399 VY 20140707
Location: NF
709.17671 HAI
Haidar, Navina Najat.
Islamic art in the Metropolitan

The Metropolitan Museum of Art, New York
In association with Scala Arts Publishers, Inc.

3 3163 01674 9399

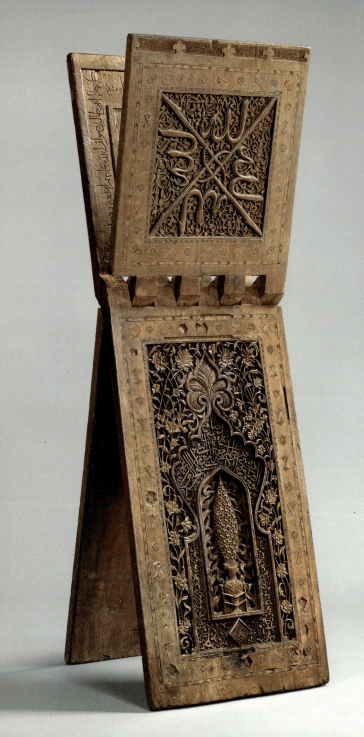

Introduction

Welcome to the Galleries for the Art of the Arab Lands, Turkey, Iran, Central Asia, and Later South Asia. These fifteen permanent galleries display works from the collection of the Museum's Department of Islamic Art in an installation that opened to the public in November 2011. The department has more than twelve thousand works of art in its holdings, drawn from an area extending from Spain to India and ranging in date from the dawn of Islam in the 7th century to the early 20th century. Today, these regions are home to more than thirty nation-states, and the cultural influence of Islam extends well beyond them as a global presence. Owing to the Museum's departmental organization and the scholarly traditions of the field, however, these galleries exhibit the art of the Islamic world just up to the modern age.

Islam, one of the world's three major monotheistic religions, arose in the Arabian Peninsula in the 7th century. It espouses faith in one God and in Muhammad, last in the line of the Abrahamic prophets. As Islam spread around the Mediterranean and through Asia, it had a profound and often unifying influence on many of the regions' artistic traditions. In the context of these galleries, Islam is intended as a wide cultural category—unified in the belief system of its adherents but diverse in its artistic expression. The civilization fostered by Islam included non-Muslim participants, who played an important role in its cultural and intellectual production.

The circular plan and multiple entry points of the galleries offer varied experiences of the art on view, but the principal entrance is located opposite the galleries of ancient Near Eastern art, which predates the Islamic material and influenced its earliest phases. If you follow the main route through the galleries (Visit One), you will trace the sweep of Islamic civilization roughly chronologically and geographically. Alternatively, you can experience the galleries in any other order, seeking out the art from particular regions—India, Spain, Iran, and so on. Proposed in this guide are three other possible routes, each allowing you to explore an important theme such as the binding thread of religion (Visit Two), princely patronage (Visit Three), or the

cultural exchanges between the Middle East, Europe, China, and India (Visit Four).

Because of their fragility and sensitivity to light, works on paper, carpets, and other textiles are rotated on and off view, and the displays are constantly changing. Some of the works reproduced in this guide, therefore, may not be exhibited during your initial visit but will return to the galleries in the future.

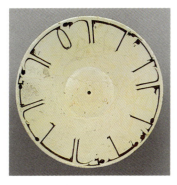

Bowl, Iran, 10th century

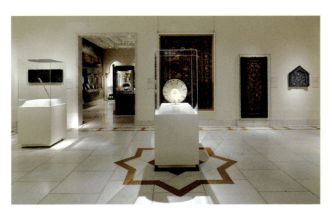

Introductory Gallery (Gallery 450)

The Islamic World, 700–1900
Major Artistic Centers

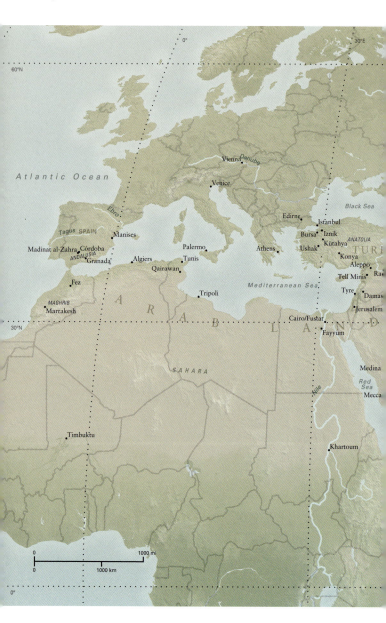

Atlantic Ocean

60°N

Vienna
Danube
Venice

Black Sea

Edirne
Istanbul
Bursa
Iznik
ANATOLIA
Ushak
Kütahya
TURKEY
Konya
Aleppo
Tell Minis
Ra...
Tyre
Damas...
Jerusalem

Tagus
SPAIN
Manises
Madinat al-Zahra
Córdoba
ANDALUSIA
Granada
Algiers
Tunis
Qairawan
Fez
MAGHRIB
Marrakesh

Palermo

Athens

Mediterranean Sea

Tripoli

Cairo/Fustat

Fayyum

30°N

ARABLAND

SAHARA

Nile

Medina
Red
Sea
Mecca

Timbuktu

Khartoum

Ebro

0°

30°E

0 1000 mi
0 1000 km

0°

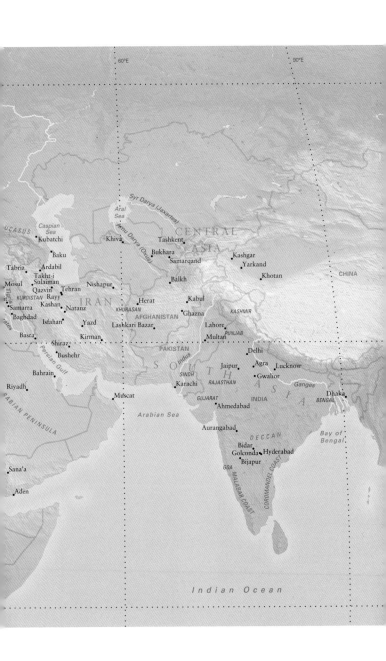

60°E

90°E

UCASUS

Caspian
Sea

Kubatchi

Baku

Tabriz
Ardabil

Mosul
Takht-i
Sulaiman

Tigris
Qazvin
Tehran
Nishapur

KURDISTAN
Rayy

Samarra
Kashan
Natanz

Baghdad
Isfahan
Yazd

ates

Basra
Kirman

Shiraz

Bushehr

Bahrain

Riyadh

RABIAN PENINSULA

Muscat

Sana'a

Aden

Aral
Sea

Syr Darya (Jaxartes)

Amu Darya (Oxus)

Khiva

Bukhara

Samarqand

Tashkent

CENTRAL
ASIA

Kashgar
Yarkand

Khotan

CHINA

Balkh

IRAN

KHURASAN

Herat

AFGHANISTAN

Kabul

Ghazna

KASHMIR

Lashkari Bazar

Lahore
PUNJAB
Multan

PAKISTAN

Indus

SOUTH

SINDH

Karachi

RAJASTHAN

GUJARAT

Delhi

Jaipur
Agra
Lucknow

Gwalior

Ganges

ASIA

Ahmedabad

INDIA

Dhaka

BENGAL

Arabian Sea

Aurangabad

DECCAN

Bay of
Bengal

Bidar
Golconda
Hyderabad

Bijapur

GOA

CORMANDEL COAST

MALABAR COAST

Indian Ocean

MAP 7

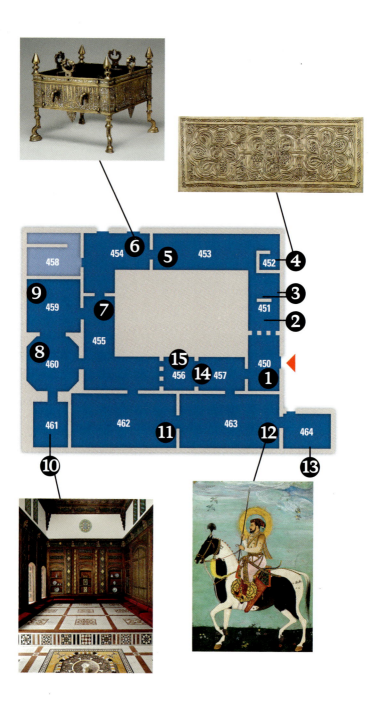

458

454 **6**

5

453

452 **4**

3

451

2

9

459

7

455

450

15

456 **14** 457

1

8

460

461

462

11

463

12

464

10

13

Tracing the Course of Islamic Civilization

This visit follows the course of Islamic civilization from its roots in the Sasanian, Byzantine, and South Arabian past through its early development in the Arab lands and Iran and subsequent spread into Turkey, Central Asia, and India. This expansion occurred initially through conquest and later through the dissemination of culture, art, and ideas. Here in the galleries, displays of the earliest Islamic art, of the Umayyad and Abbasid periods, lead into the rooms for the art and archaeology of Central Asia and Iran under the Samanids, Ghaznavids, and Seljuqs. These dynasties came under the cultural sway of the Abbasids but maintained independent modes of artistic expression. The gallery for medieval Syria and Egypt that follows focuses on the art of the Mamluks, with some precedents from the Ayyubid and Fatimid periods. Next, the art of the Persian world (Iran and Central Asia) after the Mongol conquest, particularly book painting in the influential style that peaked in the 15th century, is displayed near the large, blue-tiled prayer niche (*mihrab*) from Isfahan. In the high-ceilinged galleries for the art of the Ottoman, Safavid, and Mughal empires, a selection of the Metropolitan's collection of five hundred carpets can be seen, among many other treasures. Finally, adjoining a medieval-style Moroccan court, a gallery for the arts of the western Islamic world—Spain, North Africa, and southern Italy—houses objects on long-term loan from the Hispanic Society of America along with works from the Met's collection.

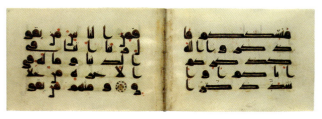

Manuscript of the Qur'an, Syria or Iraq, 9th–10th century (Gallery 450)

Masterpieces of Islamic Art

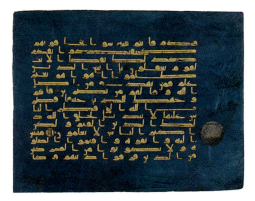

Folio from a Qur'an manuscript (the Blue Qur'an), Tunisia, 9th–10th century

This introductory gallery showcases some of the finest master-pieces in the Museum's collection of art from the Islamic world, illuminating key artistic traditions that developed in the Arab lands, Turkey, Iran, Central Asia, and South Asia from the 7th century on. On display are magnificent examples of calligraphy, objects featuring geometric and arabesque ornament in a wide range of media, and manuscript painting and illumination. Major works include pages from some of the most historically signifi-cant manuscripts of Islam's holy book, the Qur'an. Among those on view may be the Blue Qur'an (above), with its gold calligra-phy on a striking blue ground.

The early-Islamic-style three-arch colonnade guides the visitor toward the principal, chronological route through the suite of fifteen galleries. Alternatively, another doorway leads into a gallery (457) for the arts of Islamic Europe (Spain and southern Italy) and the Maghrib (North Africa), spanning eight centuries of Islam at its western reaches. Visible through the 16th-century Mughal pierced-stone screens on one wall is the gallery devoted to the arts of Mughal India (463). Thus, at the very outset of this visit, the quality and scope of the Met's collections, the variety of spaces, and the wide canvas of Islamic tradition are all apparent.

Patti Cadby Birch Gallery

Arab Lands and Iran under the Umayyads and Abbasids, 7th–13th Century

This gallery displays works of art from the earliest periods of Muslim rule in the Arabian Peninsula, the eastern Mediterranean, Iran, and Iraq. The caliphs (rulers) of the Umayyad dynasty (661–750) extended their conquests in Arabia into neighboring Byzantine and Sasanian territory. By 714 the newly formed Islamic empire stretched from Spain to India. Under the Umayyads, a fresh artistic language gradually emerged, synthesizing Late Antique and Byzantine forms from Egypt and the eastern Mediterranean, and others from Sasanian Iran, into new modes of expression; such pre-Islamic influences are evident in the style and decoration of a number of works in the gallery, such as the throne leg in the shape of a griffin and the bronze ewer with a feline-shaped handle in the freestanding cases.

The Abbasids (750–1258) overthrew the Umayyads and founded a new capital, Baghdad, in Iraq (later at Samarra). Fresh styles and techniques characterized Abbasid art, including luster-painted pottery and Chinese-inspired shapes. The influence of Abbasid wares and their ornament spread far beyond Iraq to Egypt, North Africa, and Spain as well as to Iran and modern-day Pakistan, the empire's easternmost frontier.

Golden Age of the Abbasids, 750–1258

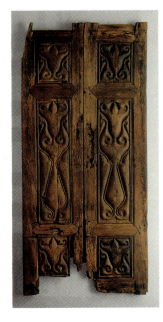

Bowl, Egypt or Syria, late 11th–
early 12th century

Beveled doors, Iraq, 9th century

The Abbasid period saw great achievements in science, philosophy, and literature at the courts in Baghdad and Samarra as well as a remarkable rise in trade. There was also artistic innovation. The development of luster painting on ceramics is seen in a number of examples exhibited together in this gallery, while two 9th-century doors carved from teak that may have been imported from Southeast Asia display the highly original "beveled" style, characterized by repeating symmetrical and curvilinear forms seemingly abstracted from nature. This influential style carried over to ceramics and glass objects of the period. Textiles, which are shown here on a rotating basis, are often embellished with inscriptions (*tiraz*), providing important evidence of patronage, production centers, and workshop organization.

The Abbasid court at Baghdad flourished until 1258, when it was claimed by the Mongol conquerors who swept through Asia from the Far East.

Archaeology and Medieval Iran

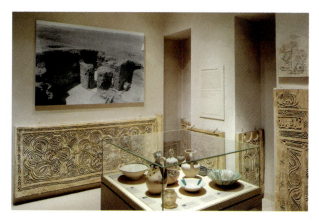

In the 1930s and 1940s, archaeologists from the Metropolitan Museum uncovered the ruins of Nishapur, Iran, a walled city that thrived from the 8th to the 10th century. Excavations revealed homes, schools, mosques, government buildings, and marketplaces. This room (named for Sabz Pushan, one of the excavation sites) is a partial reconstruction of a residential room from Nishapur. The panels of deeply carved stucco feature bold designs of stylized leaves, roundels, and palmettes, all of which were probably originally painted in bright colors. In addition to the remnants of architecture, the Museum's team discovered thousands of artifacts, including ceramics, jewelry, and toys. A selection can be seen in and around this gallery. While many of the items were produced in Nishapur, some were imported from as far away as China, reflecting Nishapur's status as an important trading center (see Visit Four).

Iran and Central Asia, 9th–13th Century

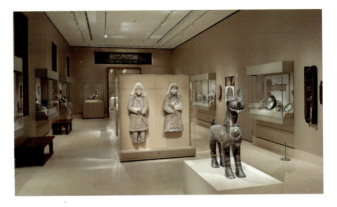

Although their authority persisted in Baghdad for another three hundred years, the political strength of the Sunni Abbasid caliphs had waned by the 10th century, and their provincial governors in Iran and Central Asia became increasingly independent. Among the most powerful dynasties in these regions were the Samanids (819–1005), in Central Asia; the Ghaznavids (977–1186), in Afghanistan, who raided northern India; and the Shi'i Buyids (945–1055), from the region south of the Caspian Sea, who seized control of Baghdad in 945. The Seljuqs (1040–1194), a Turkic clan, subsequently captured Baghdad and became the new protectors of the Abbasid caliphate and of Sunni Islam. Seljuq rulers sponsored many architectural projects, including major additions to the Great Mosque of Isfahan, in Iran, and the immense tomb of Sultan Sanjar in Merv, modern Turkmenistan.

Among the works of art exhibited from these dynastic periods are what is believed to be the world's earliest complete chess set (minus one pawn), from Nishapur, Iran; colored ceramics (*mina'i*) decorated with images from myth and literature; and a group of objects related to astrology and astronomy. Luxury metalwork and various types of ceramic production flourished under Seljuq rule in response to the wealth of the urban population.

Medieval Egypt and Syria, 10th–16th Century

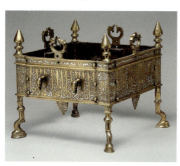

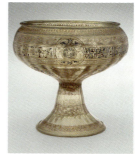

Brazier, Egypt, second half of 13th century

Footed bowl, Syria,
mid-13th century

From the 10th to the 12th century, areas around the Mediterranean
came under the rule of the Fatimid dynasty (909–1171), which
claimed descent from the Prophet's daughter Fatima. Meanwhile,
in Turkey, Seljuq power (despite having waned in Iran and Cen-
tral Asia) reached its zenith in the first half of the 13th century.
In and around northern Syria, local regimes emerged, such as the
Artuqids (1101–1409) and the Zangids (1127–1251). Objects in
the gallery from these dynasties include inlaid metalwork, glass,
ceramics, and manuscripts.

 In Egypt, Salah al-Din Ayyub (Saladin) came to power as
sultan in 1171. Despite his conquest of Jerusalem in 1187, the
Ayyubid conflict with the European Crusaders continued after
his death in 1193. To face the challenge, his successors built an
army largely of slave-soldiers (*mamluk*s), who ultimately over-
threw the last Ayyubid sultan. The vast Mamluk empire that
followed (1250–1517) reached from southern Turkey to Arabia
and incorporated Islam's holy cities, Mecca, Medina, and Jerusalem.
Its capital, Cairo, became the economic and cultural center of
the western Islamic world. Many works of art in this gallery were
produced during the Mamluk period, including a group of spec-
tacular enamel-painted glass vessels.

Iran and Central Asia, 13th–16th Century

Mongol incursions culminated in the conquest of Iran and, in 1258, the fall of the Abbasid caliphate in Baghdad. The conquerors eventually embraced Islam, ruling as the Ilkhanids (1256–1353), and introduced a new visual vocabulary partly based on Chinese forms. Numerous mosques, tombs, shrines, and royal sites were built; the Takht-i Sulaiman summer palace (ca. 1275), in northwestern Iran, was decorated with molded luster tiles featuring phoenixes (the auspicious *simurgh* of Persian tradition) and dragons.

The reign of the famous conqueror Timur, or Tamerlane (1370–1405), followed in Central Asia, Iran, Iraq, southern Russia, and part of the Indian subcontinent. The Timurids built extensively at Samarqand, in modern-day Uzbekistan (the blue-tiled *mihrab* from Isfahan in this gallery is an example of the related style in Iran). The Timurid court at Herat, Afghanistan, was home to the renowned painter Bihzad and other luminaries. In the second half of the 15th century, Turkmen dynasties, the Qara Quyunlu ("Black Sheep") and Aq Quyunlu ("White Sheep"), supplanted Timurid rule in western Iran.

By 1507 Muhammad Shaibani, an Uzbek leader, had taken both Herat and Samarqand from the Timurids. Despite the shifting regional politics, the Shaibanid rulers who followed him adopted many Timurid cultural and artistic traditions, particularly the painting style established at Bukhara, Uzbekistan.

Art of the Ottoman Empire, 14th–20th Century

Bowl, Turkey, 16th century

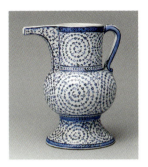

Ewer, Turkey, 16th century

This set of three successive galleries displays the art of the Ottoman empire (1299–1923); this central room, focused on the court at Istanbul, is flanked by a gallery for carpets on one side and a period room from Ottoman Damascus on the other. The Ottoman Empire was one of the most powerful and long-ruling in the Islamic world, eventually controlling most of the Mediterranean coastline, Turkey, the Balkans, the Caucasus, Iraq, Arabia, and much of North Africa. An impressive transformation of the capital, Istanbul, took place during the reign of Sultan Süleyman the Magnificent (1520–66), ushering in the golden age of Ottoman art and culture. Süleyman undertook a massive building campaign, headed by the architect Sinan, constructing great mosques with domes that rivaled the Byzantine Hagia Sophia and renovating the Topkapı royal palace.

Under Süleyman, artistic production was centralized in a variety of imperial workshops. The designs produced in these ateliers were applied to works in many media (textiles, carpets, ceramics, and metalwork), creating an identifiable style. Many of the objects on display in this central room were made by Süleyman's court artists, and others by later generations of imperial craftsmen.

Koç Family Galleries

Carpets of the Greater Ottoman World

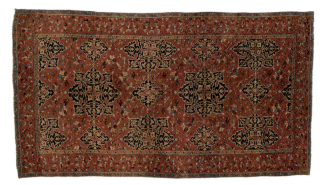

Star Ushak carpet, Turkey, early 16th century

At the height of its power in the 17th century, the Ottoman Empire controlled a vast territory, stretching from North Africa to Iraq. The villages and workshops of Turkey—the heart of the empire—produced a wide range of carpets during this period. Some display the direct influence of the Istanbul court, while others are linked to what were then already centuries-old traditions of nomadic weaving. Still others were created in commercial workshops according to a set of specific designs that proved popular in both local and international markets.

This gallery displays courtly, commercial, and village carpets of the wider Ottoman sphere under a 16th-century painted-and-gilded ceiling from Spain.

Koç Family Galleries

The Damascus Room

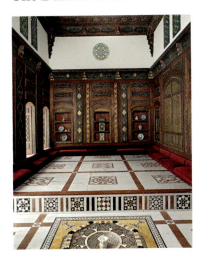

In the 18th century, Syria was under Ottoman control, and the city of Damascus was a center of trade, worship, and scholarship. This room, from a Damascus courtyard house, is the earliest extant dated interior of its type and reflects the refined and luxurious tastes of the city's elite inhabitants. The room, which would have been used for entertaining guests and family members, has painted wood panels and a fountain at its center, whose fine mosaic inlay suggests that it predates the rest of the room, possibly by three hundred years. The shelves on the back wall would have displayed prized ceramics, metalwork, and other objects collected by the owner. The designs and motifs seen throughout the woodwork reveal a variety of influences; calligraphy and honeycomb-like niches (*muqarna*s) were ubiquitous in the Islamic world, while the fruit-bowl designs painted on the wood were adopted from European art. Inscribed around the room are three poems giving praise to both the Prophet Muhammad and the house's owner. One of the poems ends above the niche (*masab*) on the right and contains the date of the room: 1707.

Gift of the Hagop Kevorkian Fund, 1970,
in memory of its founder Hagop Kevorkian

Art of Safavid Iran and Its Successors, 16th–20th Century

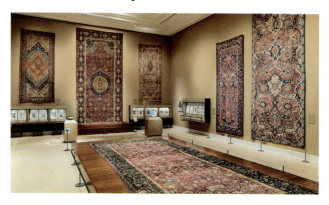

This gallery houses the art of Iran from the early 16th to the early 20th century, with works from the Safavid centers of Tabriz and Qazvin at one end and Isfahan at the other.

In the early 16th century, the Safavid dynasty (1501–1722), descended from the Sufi shaikhs (spiritual leaders) of Ardabil, in northwestern Iran, united Iran and introduced Twelver Shi'i Islam as the official state religion. Royal patronage focused on illustrated manuscripts and exquisite portable objects. The most renowned manuscript from the reign of Shah Tahmasp (1524–76) is a now-dispersed copy of the *Shahnama* (Book of Kings), of which several folios are on display here. In 1598 Shah 'Abbas (r. 1587–1629) established a new capital at Isfahan, which contains some of Iran's most famous monuments, including the Masjid-i Shah mosque. The graceful, calligraphic style of the painter Riza-yi 'Abbasi developed there and greatly influenced Persian artists and craftsmen.

After the Safavids declined, they were followed by the Afsharid (1736–47), Zand (1750–94), and Qajar (1779–1925) dynasties. During this time, new tastes in art developed, particularly for lifesize paintings, painted lacquer wares, and enamels.

Sharmin and Bijan Mossavar-Rahmani Gallery

India, 16th–19th Century

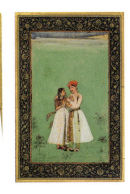

Shah Jahan on Horseback, by Payag, India, ca. 1630

Shah Shuja with a Beloved, by Govardhan, India, ca. 1632

art of the Mughal period (1526–1858)
_reat artistic achievement and cultural
synthesis. Works from the preceding Sultanate period (13th–16th century), when Islamic courts were established in northern India, are also shown, as are works from the Deccan courts of south-central India, contemporaries of the Mughals in the north.

Mughal art reflected wider and older Indian traditions as well as aspects of Persian and European practice. In painting, natural-ism and close observation were prized, not only in human por-traiture (see above, both from the Shah Jahan album, or *muraqqaʿ*) but also in animal and plant studies. The Mughal emperors' many architectural commissions included the famed Taj Mahal tomb complex (1653) in Agra. The luxury arts of the Mughal period are represented in the gallery by a group of carved jades and jeweled objects. From the 18th century on, provincial courts such as those at Lucknow and Murshidabad developed a more diffuse Mughal-inflected tradition.

The cosmopolitan courts of the Deccan had cultural ties with Iran (through shared Shiʿi traditions), Turkey, and Africa (owing to former slaves who had risen to become nobles). The region's famed textiles were exported in great quantities to Europe, the Middle East, and Southeast Asia.

Art of Rajasthan, the Punjab Hills, and British India, 16th–20th Century

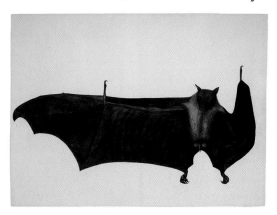

Fruit Bat, India, late 18th century

Works of art in this gallery are mainly from the courts of Rajasthan, the Punjab Hills, and the extended Mughal sphere, from Gujarat to Bengal. Beginning in the 17th century, these largely Hindu principalities in northern India gradually succumbed to Mughal rule, falling under the political and cultural sway of the imperial court while maintaining their independent, vibrant artistic traditions. When Mughal power began to decline in the 18th century, displaced artists found active patronage at the Rajput and Pahari courts. The period thus saw a flowering of regional styles all over northern India, reflecting, particularly in the art of painting, a dynamic exchange of styles between the imperial center and local courts such as those at Marwar, Mewar, Bikaner, and Kangra.

Beginning in the late 18th century, Indian artists working for colonial British patrons developed fresh subject matter and novel forms. Among the most popular were large-scale studies of plants and animals and depictions of monuments and landscapes.

Spain, North Africa, and the Western Mediterranean, 8th–19th Century

Textile fragment,
Spain, 13th century

Through both military and diplomatic efforts, Umayyad forces took control of most of the Iberian Peninsula in the 8th century, establishing an Arab and Islamic presence that endured for over seven centuries and fostering courts of phenomenal wealth and sophistication. Córdoba emerged as a brilliant cultural hub, rivaling Baghdad and Cairo.

Civil wars overthrew the Umayyad caliphate in 1031 and divided al-Andalus (Islamic Spain) into separate city-states, whose vulnerability to the reassertion of Christian power in the region brought about the intervention of two North African dynasties, the Almoravid (ca. 1062–1147) and the Almohad (1130–1269). From the disarray that followed the Almohads' ouster from Spain and the fall of Seville in 1212, one Muslim dynasty, the Nasrid (1232–1492), emerged in Granada. Meanwhile, the Marinids (1217–1465) flourished in North Africa.

This gallery exhibits the art of these regions, including southern Italy, which came under the sway of Islam during the 11th century.

Patti Cadby Birch Gallery

The Moroccan Court

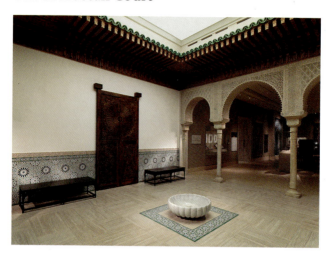

The Patti Cadby Birch Court was created at the Metropolitan Museum in 2011 by a group of craftsmen from Fez, Morocco, using traditional materials and techniques. The court is framed by four 15th-century columns from Granada, which were the basis for the overall medieval style of the decoration. The carved plaster and wood and the complex tilework (*zilij*) recall the architecture of 14th- and 15th-century Morocco and southern Spain. The star-based geometric patterns of the tilework were inspired by the tiled walls of the Alhambra palace in Granada, which was built by the Nasrid kings, the last Muslim dynasty of Spain (1232–1492). This Andalusian style of architecture was also popular in the Maghrib (North Africa), which had strong political and cultural ties to southern Spain. Remarkably, the high level of craftsmanship and knowledge of traditional techniques necessary to create a space such as this has survived in Morocco until the present day.

Patti Cadby Birch Court, made possible by the Patti and Everett B. Birch Foundation

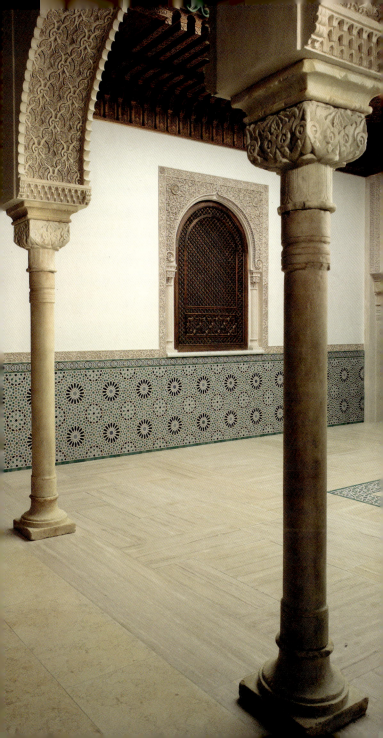

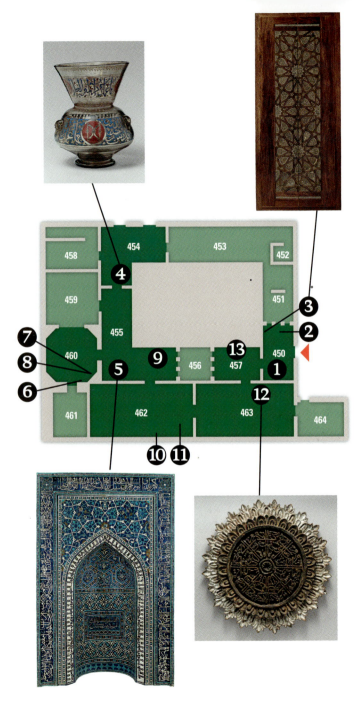

454
453
452
458
451
459
3
2
455
7
460
8
9
13
450
6
5
456
457
1
12
461
462
463
464
10
11

Dimensions of Islamic Faith and Practice

The birth of Islam in the Arabian Peninsula in the 7th century and its subsequent spread through the Arab world (including Spain and North Africa), Turkey, Iran, and Central and South Asia brought together people of markedly different cultures through their shared faith and its practice. Works of art specifically related to religion form a key to understanding the various dimensions of Islam as it evolved over fourteen centuries. Religious devotion has inspired the greatest artistic effort, leading to extraordinary beauty in objects associated with faith, from the diverse calligraphic styles developed for the Qur'an to the decoration and architecture of mosques. This visit highlights works of art that reveal the world of the pious Muslim, from prayer to pilgrimage.

Sometimes, different types of objects, motifs, and inscriptions are particular to one of the two principal sects of Islam, Shi'i and Sunni (see p. 37)—for example, the *'alam* is a parade standard often used in Shi'i processions. The influence of Sufism (Islamic mysticism) is also evident in many works in the galleries.

Some visitors are surprised to find many depictions of humans and animals here, as there is a widespread perception that such imagery is prohibited in Islam. There is no prohibition in the Qur'an, but the hadith (sayings of the Prophet) discourages figural art for two main reasons: first, to emphasize God's exclusive role as creator, and second, to warn of the dangers of idolatry. A common compromise was to confine images of people and animals to secular contexts or to small works of art intended for private enjoyment.

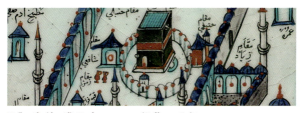

Ka'ba tile (detail), Turkey, ca. 1720 (Gallery 460)

The Qur'an and Divine Revelation

Folio from a Qur'an manuscript,
Central Asia, ca. 1400

Muslims believe the Qur'an to be the word of God as revealed to
the Prophet Muhammad by the archangel Gabriel between the
years 610 and 632. Muhammad's followers compiled these revela-
tions into their written form after the Prophet's death. The exalted
status of the Qur'an, and the practice of copying its sacred verses,
gave rise to the prestigious art of Arabic calligraphy. Qur'anic
calligraphy is always meticulous and often highly embellished.
Hanging on a wall of this gallery between two pierced-sandstone
Mughal screens is a folio from a monumental copy of the Qur'an
made in Central Asia around 1400, possibly by the calligrapher
'Umar Aqta for the Central Asian ruler Timur, known in the West
as Tamerlane. Legend relates that 'Umar Aqta set about to create
a Qur'an so small it could fit inside a signet ring, but Timur was
unimpressed, so the calligrapher went to the opposite extreme.
He produced a Qur'an so large it had to be carted in a wheel-
barrow to the palace, where he earned the ruler's lavish praise.

Patti Cadby Birch Gallery

Art and Observance at the Mosque and Madrasa

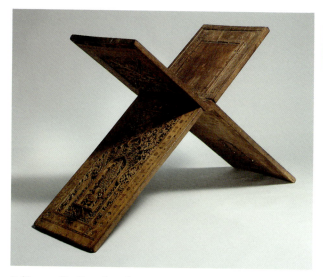

Rahla, carved by Hasan ibn Sulaiman al-Isfahani, Iran, 1360

Book stands (*rahla*s) such as the one shown above were created to hold an open manuscript of the Qur'an. Used in mosques and theological schools (madrasas), they aided in public recitation of the holy book. The central motif of this *rahla*—which appears twice, once on each "leg" of the stand—is a cypress tree enclosed within a niche. The niche recalls the shape of a prayer niche (*mihrab*), one of the key architectural features of a mosque (see p. 32) and a symbol of the gateway to paradise. To make the stand, a single piece of teak wood was split into two interlocking sections and carved to three different depths. On the longer portions, the calligraphy sits on top of a layer of scrolling arabesques; on the shorter end, arabesques appear between two layers of calligraphy—the name of God, Allah, is above, and deeper, hidden from view, lies the name of the Prophet Muhammad. The arabesques and stylized flowers hint further at the symbolism of paradise.

Patti Cadby Birch Gallery

Inside the Mosque

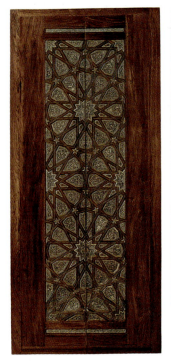

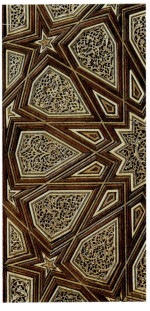

Minbar doors, Egypt, 1325–30, and detail

An important feature of the mosque interior is the *minbar*, the raised pulpit from which a sermon is delivered on Fridays. The *minbar*, which features a set of enclosed stairs leading up to a small platform, is always located near the *mihrab* (prayer niche), and together they form the focal point for communal prayer. Because of their importance, *minbar*s are often lavishly decorated. These two narrow doors were crafted from precious materials, such as imported woods and ivory, for a *minbar* in a 14th-century mosque in Cairo, Egypt. Predicated on geometric forms, the intricate, multilayered carving seems to extend past the edges of the doors in an illusion of infinite repetition. The primary decoration of interlacing twelve-pointed stars was popular in Egypt during the Mamluk period, when the doors were made.

Patti Cadby Birch Gallery

Patronage and Piety

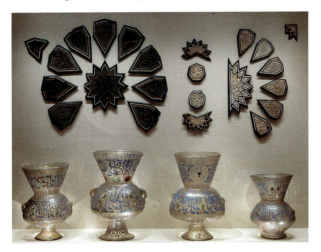

Mosque lamps and *minbar* elements, Egypt, 14th century

As the first and last daily prayers occur at sunrise and after sunset, respectively, glass oil lamps were traditionally used across the Islamic world to illuminate mosque interiors. The examples in the case shown above, from the Mamluk period in Egypt, were made of blown glass, which was then enameled and gilded with scrolling floral motifs and calligraphic inscriptions. The central two lamps include a Qur'anic quotation (24:35): "God is the light of the heavens and the earth. The semblance of his light is that of a niche in which there is a lamp." Light from the burning wick would shine through the outlines of the calligraphy, subtly uniting message and medium. Wealthy members of Mamluk society commissioned lamps and other works of art to present as pious gifts to religious institutions; their act of charity is often acknowledged in inscriptions or symbols on the objects themselves. This practice reflects one of the most important tenets of Islam: charity (*zakat*). The wood elements in the case come from 14th-century Mamluk *minbar*s and are stylistically similar to those of the *minbar* doors seen on the opposite page.

The *Mihrab* and the Five Pillars

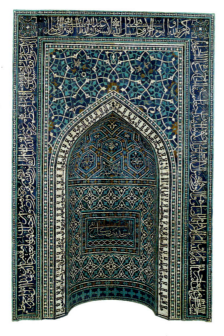

Mihrab, Iran, 1354–55

This prayer niche (*mihrab*) is from a 14th-century theological school (madrasa) in Isfahan, Iran. While students went to the mosque on Fridays to pray with the rest of their community, they could use this *mihrab* for everyday prayers without leaving the school. Its inscriptions, in three different scripts, quote the Qur'an and the hadith (sayings of the Prophet). The center of the *mihrab* contains the inscription "The Prophet Muhammad, blessings and peace be upon him, said that the mosque is the abode of the pious." The inscription that runs along the pointed arch (in angular blue letters against a white background) describes the most basic tenets of belief and practice for Muslims. These are called the Five Pillars of Islam and include the profession of faith ("There is no God but God and Muhammad is the Prophet of God"), prayer, charity, fasting (during Ramadan), and pilgrimage.

Prayer

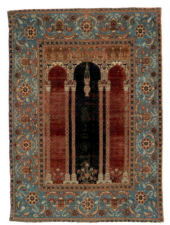

2

Prayer-style rugs, Turkey, 16th century

One of the Five Pillars of Islam is prayer, which observant Muslims perform five times a day. It is not always necessary to go to a mosque to pray; prayer can take place anywhere, as long as there is a clean surface for prostration and water for ablutions (ritual washing). Prayer rugs can be made from materials ranging from the humblest, such as straw, to the most extravagant, such as silk and silver-wrapped thread. The prayer-style rugs shown above were woven for wealthy elites of the Ottoman court by skilled artists using the finest materials. Most examples have the arched shape of a *mihrab* in the center, the top of which would be oriented toward Mecca when the rug was used. Some examples, such as the one on the left, feature architecturally realistic arches and even depict a mosque lamp suspended in the center. Others, such as the one on the right, exhibit a more abstract arch shape and abundant floral and vegetal designs that evoke the promise of paradise.

Koç Family Galleries

Pilgrimage

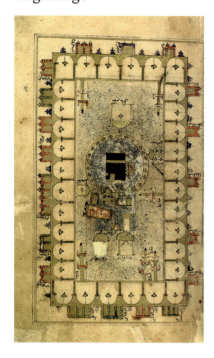

Folio from manuscript of the *Futuh al-haramain* (Description of the Holy Cities), Turkey, mid-16th century

Another of the Five Pillars of Islam is hajj: pilgrimage to Islam's holiest shrine, the Ka'ba, in Mecca, Saudi Arabia. Muslims are expected to perform the pilgrimage once in their lifetimes, if they are financially and physically able. Pilgrimage manuals illustrate the main sites visited during the hajj and describe the prayers and rituals to be performed at each. The page shown above is from a manual made in Ottoman Turkey that includes diagrammatic illustrations of the sites in both Mecca and Medina (site of the first mosque, the Prophet's home). Depicted here is Mecca with a view of the Ka'ba. Elsewhere in the manuscript, figures dressed in unstitched white robes, as stipulated for pilgrims, are shown. The inclusion of human figures is unusual, and they were probably added in Iran in the 17th century.

Koç Family Galleries

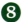

Mecca and the Ka'ba

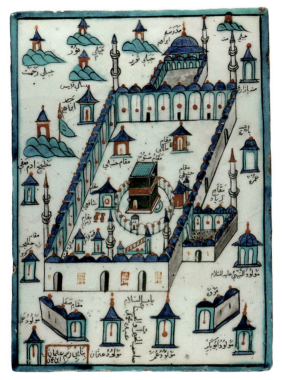

Ka'ba tile, signed by Osman ibn Mehmed, Turkey, ca. 1720

This tile depicts the city of Mecca in a stylized, bird's-eye perspective. The Ka'ba can be seen in the center of the tile, enclosed by the Masjid al-Haram mosque and other important buildings and holy sites. Mecca and the Ka'ba were favored subjects in 17th- and 18th-century Turkish tile workshops. Tiles such as this one were often placed in the *qibla* wall (the wall that faces Mecca) of mosques and wealthy private residences, where they served to remind Muslims of the importance of the hajj. Such tiles were also bought or commissioned as hajj souvenirs, which a wealthy pilgrim could display in his home as a sign of his pious act.

Koç Family Galleries

Mysticism in Islam: Poetry and Painting

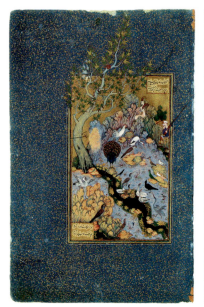

Folio from the *Mantiq al-Tair* (Language of the Birds), by Habiballah of Sava, Iran, ca. 1600, and detail

Valued by Sunni and Shi'i Muslims alike, the mystical dimensions of Islam are powerfully expressed through poetry and metaphor. Pages from illustrated manuscripts of Sufi poetry can be seen in various cases in this gallery. The *Mantiq al-Tair* (Language of the Birds), written by Farid al-Din 'Attar in Persian in the 12th century, is a metaphorical poem about the desire for unity with God—an important goal of Sufism. It describes this spiritual journey from the point of view of a group of birds who pass through seven valleys before discovering that the truth they seek is within themselves. This page shows the small crested hoopoe, leader of the expedition, addressing his avian companions before their departure.

Shiism in Safavid Iran

2

Calligraphic plaque, Iran, late 17th century

Shi'i themes came into prominence in the art of Iran's Safavid dynasty (1501–1722), whose rulers were Shi'i Muslims. The calligraphy on this pierced-steel plaque refers specifically to the founders of the Shi'i branch of Islam. The text is part of a versification of the names of the Prophet, his daughter Fatima, and the Twelve Imams (early leaders of the Shi'i community). 'Ali, a cousin of the Prophet (and Fatima's husband), is considered the first imam, in keeping with the Shi'i assertion that their leaders should be directly related to the Prophet Muhammad (as opposed to Sunnis, who believe that the leader can be chosen from any of the Prophet's followers). The plaque would likely have been part of a group set into the door of a shrine, mosque, or theological school (madrasa).

Sharmin and Bijan Mossavar-Rahmani Gallery

Sufi Metaphors in Safavid Art

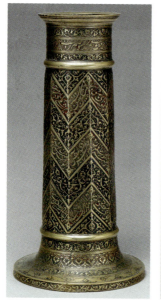

Lamp stand, Iran, 1578–79, and detail

Five brass lamp stands of the Safavid period are exhibited together in this gallery. The intricately worked surfaces of the example shown above include calligraphic inscriptions of poetic verses that reflect the influence of Sufi thought. One of the verses speaks of a moth drawn to a flame, a metaphor for the soul's powerful yearning for spiritual union with the divine, even at the cost of its annihilation. Through these inscriptions, set within chevrons of scrolling vegetal ornament, the maker created a potent link between the object's use and its decoration, turning a functional object into a vehicle for spiritual symbolism. The Safavid shahs (kings) traced their lineage to the famous 13th- to 14th-century Sufi shaikh (spiritual leader) Safi al-Din.

Sharmin and Bijan Mossavar-Rahmani Gallery

Shiism in India

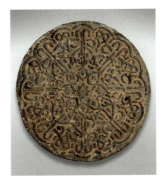 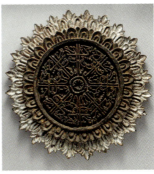

2

Calligraphic roundels, India, late 16th–early 17th century

The Deccan, a region of south-central India, was ruled by Muslim dynasties beginning in the 14th century. Some Deccan sultans claimed descent from the Safavids of Iran, and Shiism was thus an important part of their dynastic identity and was reflected in their art. Calligraphic roundels of carved sandstone or painted wood were installed in religious buildings throughout the Deccan. The sandstone example on the left features an inscription, *Ya 'Aziz* (one of the ninety-nine names of God), eight times in mirror image. Recitation of the ninety-nine names of God is a pious act for a Muslim. The first two names, Rahman and Rahim, are given in the *bismillah*, the phrase that opens the Qur'an. The wood roundel on the right is similar to some that are still in situ at Shi'i shrines in Hyderabad.

Interfaith Exchanges in Islamic Spain

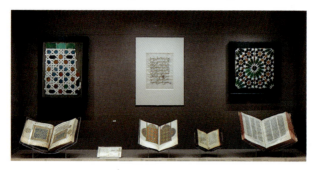

Tilework and Arabic and Hebrew manuscripts, Spain, 10th–18th century

Muslim dynasties flourished in southern Spain from the 8th to the 15th century. The cultural exchanges between Muslims, Jews, and Christians in this region led to a period sometimes referred to as the *convivencia*— "coexistence" in Spanish. The arts of these communities share many features, reflecting this interconnectedness and common approaches to the decoration of religious works and spaces. On the right side of the case shown above is a Hebrew Bible made in 1472 in Seville. Its interlacing ornamentation, comprised of tiny Hebrew letters, resembles the geometric designs and microcalligraphy found in contemporaneous Qur'ans (such as the small Qur'anic pages to the left of the Torah). The tile above it, made in the 15th century for a synagogue in Toledo, is similar in style to Spanish Islamic tilework. Multicolored tiles with intricate geometric designs were a mainstay of the architecture of both Islamic and non-Islamic communities in southern Spain and North Africa; the Patti Cadby Birch Court (gallery 456) contains modern-day examples of mosaic tilework (*zilij*).

Patti Cadby Birch Gallery

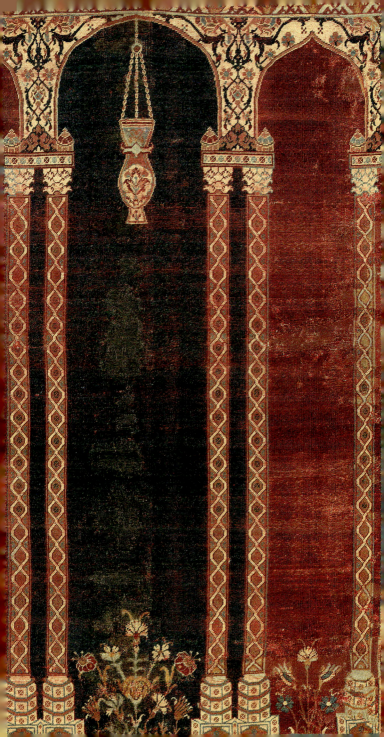

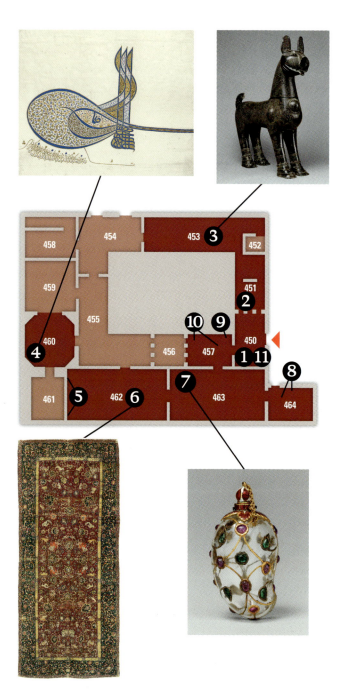

The Royal Arts

Royal patronage fostered some of the greatest art and architecture in the Islamic world. The most talented artists of the Arab, Persian, Turkish, and Indian realms were drawn to the courts, where well-organized workshop systems circulated art forms and designs across both regions and media, spreading the influence of imperial styles. Among the types of luxury objects made for royal patrons were carved ivories, such as those from Umayyad Spain; precious jades, from Mughal India; and rich carpets, from Iran, Turkey, and elsewhere. In addition to the sovereign himself, other members of the court, including nobles and women, owned and commissioned luxury objects. Perhaps the greatest cultural contributions of Islamic courts were their royal libraries, fostered and built up over centuries by successive rulers. These libraries contained valuable manuscripts made for the ruler as well as books and albums collected from around the world. Illuminated and illustrated manuscripts held the highest status, not only for their philosophical, literary, or historical content but also for the sumptuousness of their painting and production.

This visit through the galleries offers a view into the imperial sphere, as revealed in princely portraits, sumptuously decorated items for ceremonial use, and exquisite treasures, underscoring the power and influence of the ruler and his court.

3

Ivory panel (detail), Spain, 10th–11th century (Gallery 457)

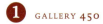

Princely Themes and Precious Materials

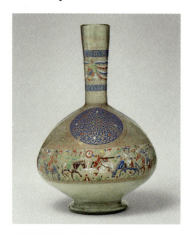

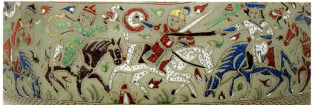

Bottle, Egypt, late 13th century, and detail

This enameled-and-gilded bottle, made in Egypt during the Mamluk dynasty (1250–1517), features both princely motifs and the luxury materials associated with royal patronage. Its sheer size and the quality of its craftsmanship also indicate that it was likely made for a ruler. The figural frieze that runs around the widest part of the bottle depicts warriors on horseback, some dressed in the costume of late 13th-century Mamluks and some in the guise of their political rivals, the Ilkhanids, who ruled Iran. The royal themes of combat and hunting occur frequently on the courtly objects in these galleries, conveying long-standing ideas about princely virility and sport.

Patti Cadby Birch Gallery

Early Islamic Kingship

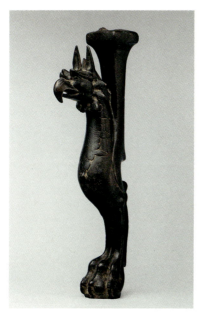

Throne leg, Iran, late
7th–early 8th century

The art of the early Islamic period is indebted to the artistic tradi-
tions that preceded the advent of Islam, namely, those of the
Sasanian and Byzantine Empires. Symbols of kingship were also
borrowed from those earlier civilizations. This throne leg from
Islam's first century takes the form of the forepart of a griffin, a
fantastic hybrid beast associated with kingship in Sasanian art.
The griffin, which has the head and wings of an eagle and the
body of a lion, may have been understood as a vehicle of ascen-
sion, such as a ruler might be imagined to ride when he is deified.
Early Islamic rulers adopted established royal symbols such as
the griffin to convey a recognizable idea of sovereignty to their
subjects. The throne itself, an obvious symbol of royalty, was
likely similar to those represented on Sasanian coins, with a flat-
topped, backless seat and four legs in the form of griffins. Images
of rulers seated on such thrones may be found in manuscript
paintings elsewhere in the galleries.

Medieval Iran

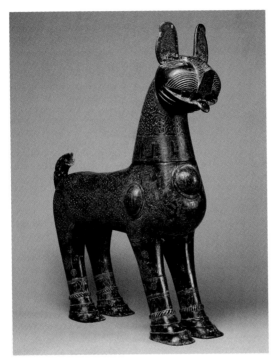

Feline-shaped incense burner, Iran, dated 1181–82

Zoomorphic incense burners, especially feline-shaped ones, were popular in Iran during the Seljuq period (ca. 1040–1196). The cast-bronze example shown above is one of the largest and most sophisticated of its type, and the regal symbolism of the lion strengthens the impression of princely origin conveyed by its size and quality. An inscription, in *kufic* script, names the work's royal patron: "Ordered by the just and wise prince Saif al-Dunya wa'l-Din ibn Muhammad al-Mawardi." Other inscriptions name the artist, give the date of production, and offer good wishes. The head is removable so that coal and incense could be placed inside; when the burner was lit, scented smoke would emanate from the decorative openwork of the body.

Imperial Patronage at the Ottoman Court

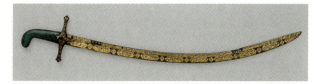

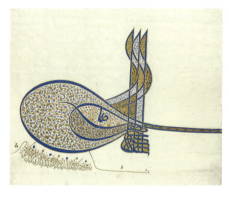

Saber and cipher of
Sultan Süleyman the
Magnificent, Turkey,
16th century

The Ottoman Empire (1299–1923) was one of the most powerful
and longest-ruling in the Islamic world. At its height in the 17th
century, it controlled lands stretching from North Africa and
parts of Europe to the Persian Gulf. At its court at Istanbul, the
finest artists, drawn from all over the empire, created precious
works of art for the sultan and his courtiers. One of the corner cases
in this gallery contains works associated with Sultan Süleyman
the Magnificent, whose reign (1520–66) is considered part of the
golden age of Ottoman art and culture. Often displayed in the case
is the sultan's official ensign (*tughra*), whose elaborate ornamen-
tation and complex calligraphy included his many titles. The
saber is a masterpiece of Ottoman arms; its calligraphic inscrip-
tions, in dark steel, stand out in relief against a background cut
away and inlaid with gold. In all likelihood, the saber would have
been worn by Süleyman during processions and other court cere-
monies, not used in battle.

Koç Family Galleries

A King's Book of Kings

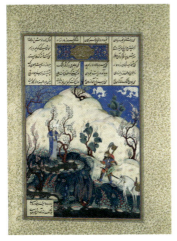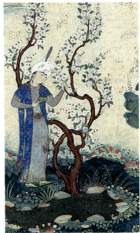

Kai Khusrau Is Discovered by Giv, attributed to Qadimi, Iran, 1525–35, and detail

The Safavids of Iran (1501–1722) were avid patrons of the arts, and their court workshops produced some of the finest illustrated manuscripts in the world. The *Shahnama* (Book of Kings) is an epic history of Persia (ancient Iran), compiled and versified in the early 11th century by the poet Firdausi. It covers the mythical past up to the conquest by Arab Muslims in the 7th century. The page shown above is from a manuscript of the *Shahnama* commissioned by Shah Tahmasp in 1524, the first year of his fifty-two-year reign. Shah Tahmasp's manuscript was one of the longest and most luxurious copies of the *Shahnama*; it contained 759 pages of text and 258 painted illustrations embellished with silver and gold leaf. Seventy-eight of the illustrated pages are in the Metropolitan's collection and are shown on a rotating basis in this gallery. The images feature a range of subjects, from combat and royal succession to love and courtship.

Sharmin and Bijan Mossavar-Rahmani Gallery

Carpets for Royal Courts

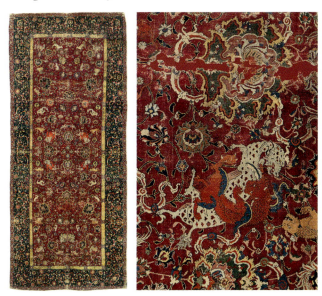

The Emperor's Carpet, Iran, 16th century, and detail

Large, sumptuous carpets were produced for the Safavid shah (king) and his court by the royal workshop, which employed the most skillful craftsmen and had access to the finest materials (silk and precious metals). Because of their status as luxury objects of the highest quality, Safavid carpets became desirable in the West as well and often found their way to the palaces of European royalty. One of the most famous examples, the so-called Emperor's Carpet (above), is said to have belonged to Peter the Great of Russia and later to the Habsburg royal family of Austria. It displays classical Safavid motifs and designs, such as scrolling vines, arabesques, flowers, and brightly colored animals, often in combat.

Sharmin and Bijan Mossavar-Rahmani Gallery

Luxury Arts of Mughal India

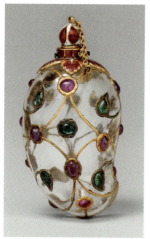

Mango-shaped flask, India,
mid-17th century

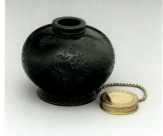

Ink pot, signed by Mu'min, India,
1618–19

The Mughals ruled a large expanse of the Indian subcontinent
from the 16th to the 19th century (1526–1858). Their active
patronage of art and architecture can be seen in the Taj Mahal, the
famous marble-inlaid tomb at Agra, where their taste for gran-
deur was most lavishly expressed. Imperial workshops brought
together artists from many corners of the empire and beyond,
including Persian painters and European jewelers. The Mughal
emperors' love of luxury can be seen in the tiny mango-shaped
flask shown above, whose body of rock crystal is encased in a
delicate web of gold and studded with rubies and emeralds. The
jade ink pot with a gold stopper was made for Emperor Jahangir,
who reigned from 1605 to 1627. Its rounded form and thick walls
convey its sturdy functionality, while the engraved decoration of
cloud bands and flowers shows the skill of its maker, Mu'min,
who signed and dated it 1618–19.

Royal Arts of the Deccan

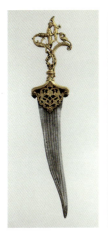

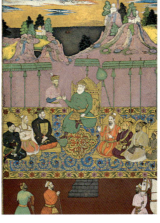

Dagger, India, ca. 1600

The House of Bijapur, by Kamal Muhammad and Chand Muhammad, India, 1680

The painting shown above, regularly on view in this gallery, was commissioned by the last ruler of the Bijapur dynasty, in the Deccan (south-central India), shortly before the kingdom fell to Mughal conquerors in 1686. Bijapur's 'Adil Shahi rulers claimed lineage from the Safavid dynasty of Iran. The painting aptly illustrates that claim of royal legitimacy—it shows the founder of the Safavid dynasty, Shah Isma'il (erroneously identified in the inscription as Shah 'Abbas), handing a key to Yusuf, the founder of the Bijapur dynasty. Seated around them are members of the House of Bijapur from throughout the family's two-hundred-year rule, wearing ceremonial daggers at their sides. One of the finest examples of a related type of dagger is shown to the left. The ruby-studded hilt features interlocking zoomorphic imagery, and the combination of animals reflects the varied traditions of the Deccan region, which incorporated influences from Iran (in the form of a deer and hunting feline), Europe (the dragon, whose tail wraps around the grip), and the neighboring Vijayanagar Empire (the bird holding a shrunken snake).

Court Arts of Madinat al-Zahra

Ivory panel, Spain, 10th–early 11th century

The Spanish Umayyad caliphs (756–1031) built a glorious city on the outskirts of Córdoba called Madinat al-Zahra (literally, "beautiful city"), where many palatial ruins and works of art have been unearthed. The ivories displayed in the case beside this gallery's exit are examples of the luxury objects produced at that court, which were imbued with the taste and sophistication of the Spanish Umayyad artists and their royal patrons. The precious material was carved with lacelike intricacy into motifs ranging from simple scrolling vines and flowers to dancing figures and animals. The panel shown above, which once adorned the side of a rectangular container, or casket, was carved from a single piece of ivory in a twice-repeating pattern. The eyes of the human figures and animals are drilled and once were filled with minute semiprecious stones. The ivory pyxides in the case, one of which is on loan from the Hispanic Society of America, were likely commissioned by members of the court to hold perfume and other precious substances. An inscription on a similar ivory container suggests that such objects were often presented as gifts to ladies of the court.

Patti Cadby Birch Gallery

Art and Architecture of the Nasrid Court

Ceiling panel and Qur'an case, Spain, 14th–15th century

3

The Nasrid sultans (1232–1492) of Granada, Spain, are perhaps most famous for the dazzling Alhambra palace, one of the greatest Islamic monuments in the West. The carved-wood panel installed overhead was once part of a ceiling, possibly from a long gallery in the Alhambra. Its four miniature domes and interlocking pattern of stars and hexagons would originally have been painted in many colors and gilded. The Nasrid kingdom lasted until the 15th century, when its last sultan, Muhammad XII (known in the West as Boabdil), was driven out of Spain by the Catholic armies of Aragon and Castile under King Ferdinand and Queen Isabella. The Qur'an holder shown above is said to have belonged to Boabdil himself. It is embroidered with precious silver-gilt-wrapped wires, and the front bears the Nasrid dynastic motto in Arabic ("There is no Victor but God"), set against a background of scrolling vine motifs. The presence of the motto, paired with the repetition of the Nasrid crest at the bottom left and right corners, supports the royal provenance of the piece.

Patti Cadby Birch Gallery

Emblems of Kingship

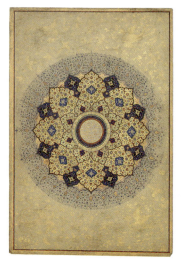

Folio from the Shah Jahan Album, India, 1645

The Mughal emperor Jahangir was an avid connoisseur who collected calligraphy and painting throughout his life. His son and successor, Shah Jahan (r. 1628–58), continued his activities, eventually compiling the pages in a royal album. In their intricate ornamentation, virtuosic drawing, often courtly subject matter, and sumptuous use of gold and pigment made from lapis lazuli (a semiprecious blue stone), these pages epitomize royal patronage. Introductory pages from the album are displayed in this gallery on a rotating basis. The page featuring an elaborate *shamsa* (sunburst design) contains an inscription that names Shah Jahan as the patron of the album: "His Majesty Shihab al-Din Muhammad Shah Jahan, the king, the vanquisher, may God perpetuate his dominion and sovereignty." In addition to the pages of calligraphy—which extol the beauty of the art form and the skill of the calligrapher—and remarkably detailed paintings of plants and animals, the album contains portraits of the royal family and various dignitaries. Other pages from this sumptuous album are on view in gallery 463.

Patti Cadby Birch Gallery

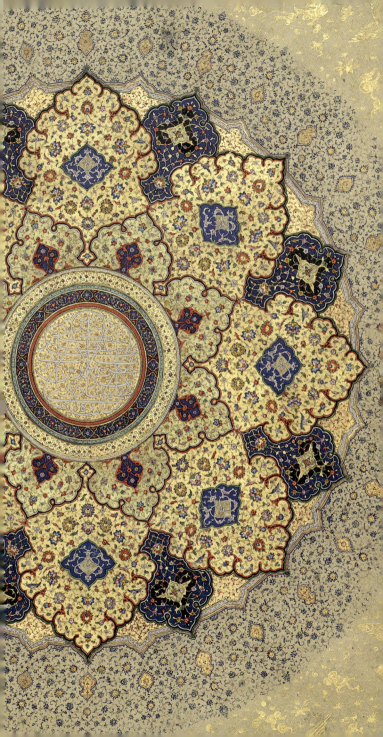

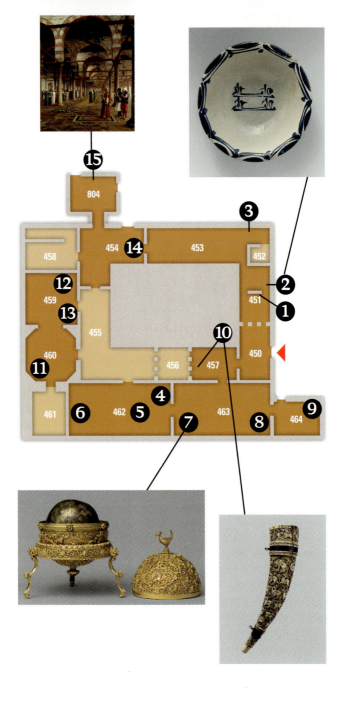

Interconnections and Cultural Exchange

O ver the centuries, networks of exchange developed among the many cultures of the Islamic world that enabled the movement of people and ideas and the mutual influence of forms and styles of artistic expression. Such exchanges also occurred between the Islamic world and India (home to multiple cultures and religions, including Islam), China, and Europe. This visit examines works of art in the Galleries for the Art of the Arab Lands, Turkey, Iran, Central Asia, and Later South Asia—and elsewhere in the Museum—that reflect such cultural exchanges.

Trade routes with China influenced ceramic production in the Near East in the early and medieval Islamic periods and had a renewed impact after the Mongol conquest of Baghdad in the mid-13th century. Still later, the reaction to Chinese styles was seen in the blue-and-white and celadon-colored wares of Iran, Turkey, and other regions. Styles and motifs in painting and architectural decoration also reveal the influence of China, especially the widespread use of cloud bands in various media and the appearance of phoenixes and dragons on royal buildings and objects in Iran. European exchanges with the Islamic world are woven into art in a similar way; they are evident, for example, in new approaches to perspective, modeling, and volume in Mughal painting in the 16th century and in the presence of Islamic carpets and scenes in European painting. This visit explores how trade, diplomacy, and colonialism all played a role in the circulation and exchange of artistic ideas in the Islamic world and beyond.

Tile panel (detail), Iran, 17th century (Gallery 462)

Late Antiquity and Early Islam

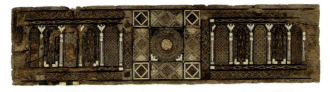

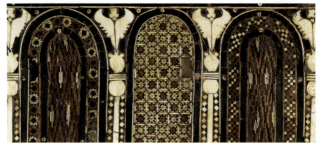

Panel, Egypt, 8th century, and detail

This panel was likely part of a large container, perhaps a casket or a repository of volumes of the Qur'an. Made in Egypt in the 8th century, it reflects both ancient Roman and Sasanian (pre-Islamic Persian) influences. It is a rare early example of wood-mosaic decoration, and its intricately inlaid tesserae are reminiscent of Roman floor mosaics. At the very center of the panel is a disk with scrolling grapevines, a late Roman motif; around this, a central square is flanked by six white columns surmounted by a double-winged motif that is reminiscent of Sasanian crowns. In its combination of techniques and stylistic influences, the panel demonstrates early Islamic artists' appropriation of earlier artistic traditions and the continued interconnectedness of the regions where they lived.

If you wish to explore these connections further, visit the galleries for Ancient Near Eastern art (400–406). You will find Roman and Byzantine floor mosaics downstairs, in galleries 168 and 301.

China and Abbasid Iraq

Bowls, Iraq, 9th century

China and the Islamic world maintained close economic and cultural ties from the 7th century on. The ancient system of interconnected trade routes reaching from eastern China to the Mediterranean Sea, sometimes known as the Silk Road, facilitated the movement of people, goods, and ideas from one region to another. These two bowls were made in Basra, Iraq, in the 9th century. Both feature opaque-white-glazed backgrounds that may have been an attempt to mimic Chinese porcelain, which was much admired in the Islamic world but impossible to reproduce with local ingredients. The bowl on the left is of a type known as splashware, so named for the drips of green glaze that decorate its interior. Splashware originated in China, where it is called *sancai* (literally, "three color") ware. Iraqi examples such as this probably owe their design to Chinese originals that had made their way along the Silk Road to Iraq and Iran. The other bowl may demonstrate influence in the other direction; it is one of the earliest examples of the blue-and-white palette that eventually became an integral part of the Chinese visual repertoire.

Many examples of Chinese ceramics are displayed on the Great Hall Balcony (galleries 202–205).

China and Medieval Iran

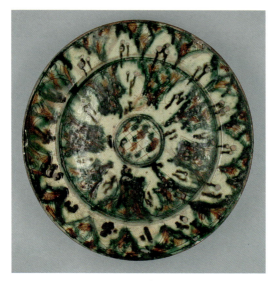

Bowl, Iran, 10th century

Nishapur was an important urban center in medieval Iran, with a thriving commercial and cultural life. Excavations there reveal the presence of both Basra splashware (such as the green-and-white bowl on the previous page) and *sancai* wares imported from China. The bottom shelf of the large case outside gallery 452 holds two fragments (one brown, one green) of Chinese ceramics imported into Nishapur. Alongside these are several examples of green-and-brown splashware that were likely made in Nishapur itself. The sheer number of splashware vessels found at Nishapur attests to their popularity with the affluent inhabitants of that city and suggests that Nishapur had its own, local manufactory.

Examples of Chinese *sancai* ware are on view on the Great Hall Balcony, in gallery 205.

China and Safavid Iran

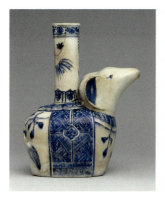

Kendi, Iran, ca. 1625–50

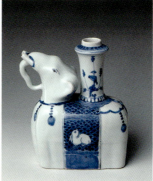

Kendi, China, late 16th century

4

Many ceramics made in Iran under Safavid rule (1501–1722) show the continued influence of Chinese ceramic shapes, color palettes, and designs. A case in this gallery contains both Safavid and Chinese porcelain vessels; together, the works reflect a long-standing artistic dialogue between China and Iran. This is perhaps most evident in two elephant-shaped water vessels (*kendi*s); despite remarkable similarities in color, design, and shape, one was made in Iran and the other in China. Chinese blue-and-white porcelain was avidly collected by the Safavid shahs (kings) and court elites, and Persian artists often made copies of Chinese originals. Imported Chinese blue-and-white porcelain was so highly prized in Iran that it was used in official gift giving, as in Shah Isma'il's gift of hundreds of blue-and-white vessels to the shrine at Ardabil of his dynasty's founder, the Sufi shaikh (spiritual leader) Safi al-Din, in 1609.

See more Chinese blue-and-white porcelain on the Great Hall Balcony and at the top of the Grand Staircase (galleries 200, 203, and 204).

Sharmin and Bijan Mossavar-Rahmani Gallery

Europe and Safavid Iran

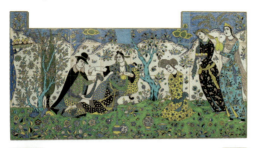

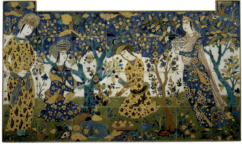

Tile panels, Iran, 17th century

These tile panels probably adorned the walls of a Safavid garden palace in Isfahan, Iran, in the first quarter of the 17th century, and their imagery reflects the pastimes, pleasures, and tastes of that city's elite. Executed in a palette of brilliant blues, yellows, and greens, the scenes show courtiers relaxing in a lush garden. Most of the figures wear the richly patterned robes, silk sashes, and striped turbans typical of 17th-century Persian dress; the kneeling man on the left of the top composition, however, wears a distinctly European cloak and brimmed hat. European visitors were not uncommon in Isfahan, and the presence of European costume in these scenes reflects a taste for "Occidentalism" in the art of the Safavid court—the result of ever-growing contact with Europe.

Sharmin and Bijan Mossavar-Rahmani Gallery

"Polonaise" Carpets in Europe and Iran

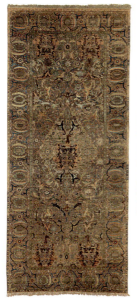
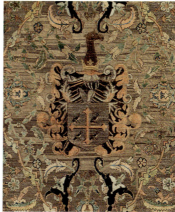

The Czartoryski Carpet, Iran, 17th century, and detail

4

Safavid Iran and parts of eastern Europe found themselves unlikely allies during the 17th century because of their common enmity toward the expanding Ottoman Empire, which threatened Iran in the east and Poland and Hungary in the north. Diplomatic ties were cemented though the exchange of gifts, such as valuable silk carpets. Safavid workshops responsible for weaving carpets for the Persian market also created carpets specifically for Europeans. A group of soft-colored silk "Polonaise" carpets are so named because a coat of arms originally thought to be Polish appears on this well-known example, which was displayed in Paris in 1878. The colors, designs, and sumptuous materials (silk and, often, gold- and silver-wrapped thread) of Polonaise carpets may have been chosen with European tastes in mind. The occasional presence of European coats of arms suggests that they were sometimes commissioned by Europeans themselves or given to them by Safavid rulers as diplomatic gifts.

Sharmin and Bijan Mossavar-Rahmani Gallery

Europe and Western India

Goa stone and container, India, ca. 1700

In the late 17th century, Jesuit priests in Goa, a Portuguese colony on the west coast of India, manufactured unusual objects known as Goa stones—manmade versions of bezoars (animals' gallstones) consisting of clay, crushed gemstones, and many other ingredients, finished with a layer of gilding. These stones were thought to possess protective and healing powers, whether they were scraped off a sliver at a time and ingested or kept intact as talismans. Goa stones were both sold locally and exported to Europe, where they were much sought after. This intricately ornamented container for a Goa stone displays an interesting synthesis of artistic influences. Pierced, chased, and chiseled into the gold is an overall scrolling vine motif, or arabesque. Superimposed over the vines is a trellis of decorative cartouches containing animals common in Indian art (stags, monkeys, and gazelles) as well as European mythical beasts (unicorns and griffins).

Other works featuring the animals mentioned above may be found in galleries 234–242 (Indian sculpture) and 300–307 (medieval European art).

Europe and Deccan India

 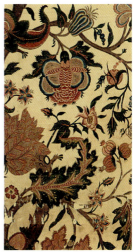

4

Palampore, India, 18th century, and detail

The palampore (bedspread or wall hanging, from the Hindi word *palangposh*) shown above was made in Deccan India in the late 17th century and is an example of a type of textile produced largely for the European market. Palampores' designs deliberately responded to European taste, and their size and format matched European bed sizes. The decorations are most often floral or vegetal, combining elements of traditional Indian textiles and English embroideries, which themselves were influenced by Dutch still-life paintings and Chinese textiles. Appealing to European customers but created by Indian artisans, these textiles are representative of the strong trade connections between East and West in the 18th century.

The Museum's Antonio Ratti Textile Center (gallery 599) has rotating exhibitions of textiles from various parts of the world, while the Tapestry Room from Croome Court (gallery 516) exhibits the taste for florals that prevailed in 1760s England.

European Motifs in India

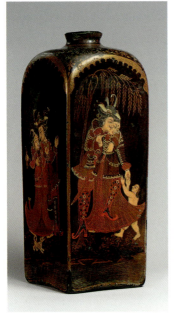
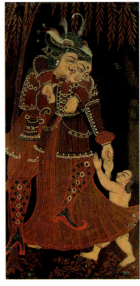

Bottle, India, ca. 1800

European figures sporting plumed hats, boots, and other foreign accoutrements were pictured in many schools of Indian painting, including at the Rajput courts, where foreigners were well known by the late 18th century. This painted glass bottle from Kota, Rajasthan, has a square form; such bottles were sometimes known as gin bottles, their shape recalling that of taller German and Dutch bottles that held the liquor. Perhaps this shape inspired the decoration, which shows, among other motifs, a culturally mixed family—Europeanized man, Indian woman, and young child.

Sicily and Fatimid Egypt

<div style="float:right">4</div>

Parts of Spain, Portugal, North Africa, and Italy were ruled by Muslim kingdoms from the 8th to the 15th century. By the mid-9th century, Arab Muslims controlled parts of southern Italy and much of the island of Sicily, which had previously been a province of the Byzantine Empire. In the case shown above are objects from Islamic Sicily, including an elaborately carved ivory oliphant, or horn. Such objects were most likely produced by Muslim craftsmen who continued to live and work in Sicily and southern Italy after control shifted to the Normans in the 11th century. Many of the other works in the gallery, including the luxury ceramics known as lusterware, reflect a similar convergence of cultures and the continuation of Islamic artistic practices under Christian patronage.

Gallery 950, in the wing of the Museum devoted to the Robert Lehman Collection, contains many examples of majolica (Italian tin-glazed earthenware). Some non-Islamic Spanish lusterware may also be found downstairs in gallery 307.

Patti Cadby Birch Gallery

Ottoman Turkey and Buddhism

Dish, Turkey, late 16th century

The decoration on this dish is a variant of the so-called *cintamani* (Sanskrit for "auspicious jewel") design. Appearing on Turkish ceramics as well as on carpets and textiles, the design originated in Buddhist iconography, which was widely known and perpetuated throughout Asia. Originally, in Buddhist images, the jewels were represented as flaming pearls, but in the Ottoman context they became circles and wavy stripes. Here, their meaning was transformed through their association with tiger stripes and leopard spots, symbols connoting strength and courage.

Buddhist art from the Himalayan region is on view in galleries 252 and 253.

Koç Family Galleries

Turkish Carpets in Europe

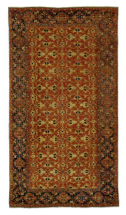

Lotto carpet, Turkey, 17th century; Nicolaes Maes, *Young Woman Peeling Apples*, 1655

4

Turkish carpets were much admired in Europe and began appearing in European paintings as early as the 13th century. During this early period, they were most often depicted in religious scenes, such as those featuring the Madonna and Child, reflecting their status as precious luxury objects. In the 17th century, however, they began appearing in everyday scenes as well. The practice became so common that many types of Turkish carpets are known today by the names of painters who often depicted them, such as Hans Holbein, Lorenzo Lotto, and Giovanni Bellini. Carpets were especially popular with the painters of Dutch genre scenes, such as Nicolaes Maes. In the work shown above (on view in gallery 634), a large carpet is used as a tablecloth. The red-and-yellow interlace design in its main field identifies it as a Lotto carpet, not unlike the above example. The prevalence of Islamic carpets in European paintings of this period points to their complete assimilation into European visual culture; by the 17th century, they were seen no longer as exotic adornments but rather as luxury items appropriate in any well-appointed home.

See the Museum's extensive holdings of 17th-century Dutch painting in galleries 631–638.

Koç Family Galleries

Maritime Exchanges in the Mediterranean

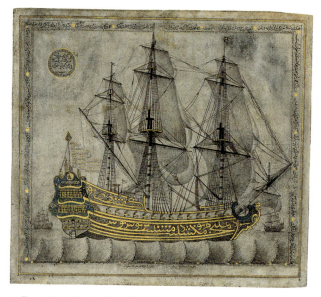

Calligraphic Galleon, by 'Abd al-Qadir Hisari, Turkey, 1766–67

Following the expansion of maritime routes during Europe's Age of Exploration (15th–16th century), depictions of ships, often European ones, began to appear in Islamic painting. This type of image, composed almost entirely from calligraphy, is called a calligram and was particularly popular in Ottoman Turkey. The body of the Ottoman galleon is made up of the names of the Seven Sleepers and their dog, with further miniaturized calligraphy (containing prayers and the titles of the sultan) appearing along the waves, in the borders, and elsewhere in the composition. The tale of the Seven Sleepers, found in the Qur'an and adapted from pre-Islamic Christian sources, concerns a group of men who sleep for centuries within a cave, protected by God from religious persecution. Both the hadith (sayings of the Prophet) and the *tafsir* (commentaries on the Qur'an) suggest that the Qur'anic verses have talismanic qualities.

Koç Family Galleries

Scientific Developments in the Medieval World

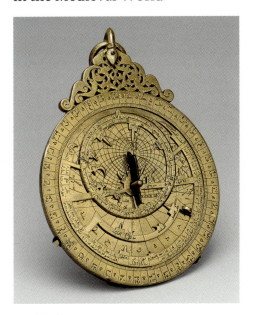

Astrolabe, Yemen, 1291

4

Invented in ancient Greece, the astrolabe is a sophisticated tool for observing the position of the stars. In early Islam, when scientific studies flourished, astrolabes were vastly improved and widely used to determine the correct times for Muslim prayers and the correct direction to face. Through Islamic Spain the astrolabe was introduced to Europe, and in the Middle Ages, sailors employed the device to stay on course during their ocean journeys. The present piece contains an inscription attributing it to a Rasulid prince of Yemen, 'Umar ibn Yusuf, who is known to have compiled a number of treatises related to the sciences.

European Orientalism

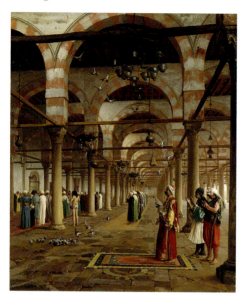

Jean-Léon Gérôme, *Prayer in the Mosque*, 1871

The 19th century saw major shifts in the nature of global interconnections. France, the Netherlands, England, and other countries began colonizing large areas of the Middle East and Africa, leading to increased awareness of and interest in the East on the part of many Europeans. A genre of academic painting known as Orientalism developed in France, and painters such as Jean-Léon Gérôme created scenes of the "exotic Orient," often focusing on the bathhouse, the mosque, and the harem—which evolved into the ubiquitous European subject of the odalisque, or concubine. The figures in this painting were likely sketched elsewhere and inserted into the imagined scene by Gérôme in his Paris studio; the depictions of an Indian mendicant and a heavily armed man are especially fanciful, as neither would have set foot in an actual mosque. This gallery of European paintings, appropriately adjoining the Islamic galleries, gives us a glimpse into the age of colonialism and the Islamic world as seen through 19th-century European eyes.

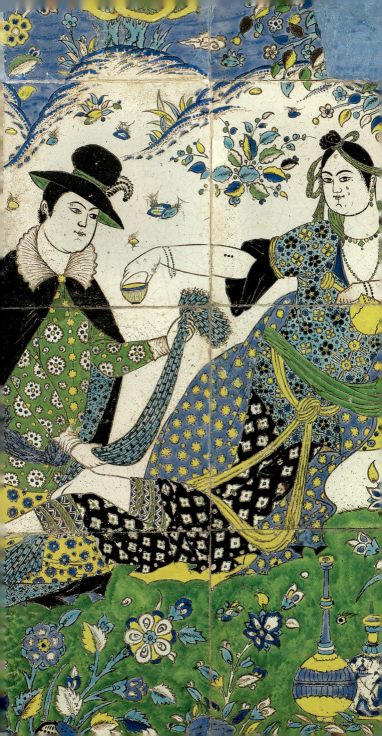

Chronology of Major Empires and Dynasties in the Islamic World

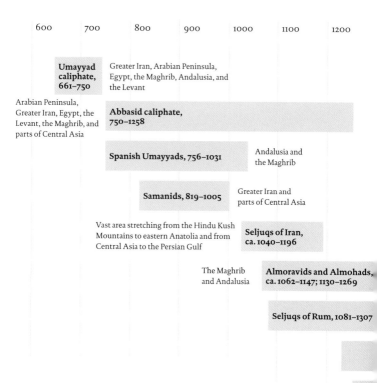

| 600 | 700 | 800 | 900 | 1000 | 1100 | 1200 |

Umayyad caliphate, 661–750
Greater Iran, Arabian Peninsula, Egypt, the Maghrib, Andalusia, and the Levant

Arabian Peninsula, Greater Iran, Egypt, the Levant, the Maghrib, and parts of Central Asia

Abbasid caliphate, 750–1258

Spanish Umayyads, 756–1031
Andalusia and the Maghrib

Samanids, 819–1005
Greater Iran and parts of Central Asia

Vast area stretching from the Hindu Kush Mountains to eastern Anatolia and from Central Asia to the Persian Gulf
Seljuqs of Iran, ca. 1040–1196

The Maghrib and Andalusia
Almoravids and Almohads, ca. 1062–1147; 1130–1269

Seljuqs of Rum, 1081–1307

This chronology aims to place the major empires and dynasties mentioned in this guide into a historical and geographical framework. The general regions ruled by each dynasty are indicated here, but it is important to note that boundaries often varied depending on territorial gains and losses.

1300	1400	1500	1600	1700	1800	1900

Most of Anatolia

Nasrid kingdom, 1232–1492 Parts of Andalusia

Mamluks, 1250–1517 Egypt, parts of the Arabian Peninsula, and the Levant

Ilkhanids, 1256–1353 Greater Iran, the Caucasus, and parts of Central Asia

Anatolia; parts of the Balkan Peninsula and eastern Europe; parts of the Maghrib (excluding Morocco), the Levant, and the Arabian Peninsula; and Egypt

Ottoman Empire, 1299–1923

Timurid Empire, 1370–1507 Greater Iran and parts of Central Asia

Greater Iran and parts of Central Asia and the Caucasus **Safavid Empire, 1501–1722**

Most of the Indian subcontinent and parts of present-day Afghanistan **Mughal Empire, 1526–1858**

Donor Credits

p. 2: 10.218 Rogers Fund, 1910

p. 5: 65.106.2 Rogers Fund, 1965

p. 9: 37.142 Gift of Philip Hofer, 1937

p. 10: 2004.88 Purchase, Lila Acheson Wallace Gift, 2004

p. 12: 31.119.1, .2 Fletcher Fund, 1931; 1975.32.2 Fletcher Fund, 1975

p. 15: 91.1.540, 91.1.1538 Edward C. Moore Collection, Bequest of Edward C. Moore, 1891

p. 17: 17.120.19 Mr. and Mrs. Isaac D. Fletcher Collection, Bequest of Isaac D. Fletcher, 1917; 66.4.3a, b Harris Brisbane Dick Fund, 1966

p. 18: 58.63 Gift of Joseph V. McMullan, 1958

p. 19: 1970.170 Gift of The Hagop Kevorkian Fund, 1970

p. 21: 55.121.10.21, 55.121.10.35 Purchase, Rogers Fund and The Kevorkian Foundation Gift, 1955

p. 22: 2008.312 Purchase, Anonymous Gift, Cynthia Hazen Polsky Gift, Virginia G. LeCount Bequest, in memory of The LeCount Family, 2007 Benefit Fund, Louis V. Bell, Harris Brisbane Dick, Fletcher, and Rogers Funds and Joseph Pulitzer Bequest, and Gift of Dr. Mortimer D. Sackler, Theresa Sackler and Family, 2008

p. 23: 28.194 Rogers Fund, 1928

p. 27: 2012.337 Gift of John and Fausta Eskenazi, in memory of Victor H. Eskenazi, 2012

p. 28: 18.17.1, .2 Gift of Samuel T. Peters, 1918; 21.26.12 Rogers Fund, 1921

p. 29: 10.218 Rogers Fund, 1910

p. 30: 91.1.2064 Edward C. Moore Collection, Bequest of Edward C. Moore, 1891

p. 32: 39.20 Harris Brisbane Dick Fund, 1939

p. 33: 22.100.51 The James F. Ballard Collection, Gift of James F. Ballard, 1922; 1974.149.1 Bequest of Joseph V. McMullan, 1973

p. 34: 32.131 Rogers Fund, 1932

p. 35: 2012.337 Gift of John and Fausta Eskenazi, in memory of Victor H. Eskenazi, 2012

p. 36: 63.210.11 Fletcher Fund, 1963

p. 37: 1987.14 Rogers Fund, 1987

p. 38: 29.53 Rogers Fund, 1929

p. 39: 1985.240.1 Edward Pearce Casey Fund, 1985; 1991.233 Purchase, Richard S. Perkins and Alastair B. Martin Gifts and Rogers Fund, 1991

p. 41: 22.100.51 The James F. Ballard Collection, Gift of James F. Ballard, 1922

p. 43: 13.141 John Stewart Kennedy Fund, 1913

p. 44: 41.150 Rogers Fund, 1941

p. 45: 1971.143 Purchase, Joseph Pulitzer Bequest, 1971

p. 46: 51.56 Rogers Fund, 1951

p. 47: 36.25.1297 Bequest of George C. Stone, 1935; 38.149.2 Rogers Fund, 1938

p. 48: 1970.301.32 Gift of Arthur A. Houghton Jr., 1970

p. 49: 43.121.1 Rogers Fund, 1943

p. 50: 1993.18 Purchase, Mrs. Charles Wrightsman Gift, 1993; 29.145.2 The Sylmaris Collection, Gift of George Coe Graves, 1929

p. 51: 2011.236 Purchase, Lila Acheson Wallace Gift, 2011; 1982.213 Purchase, Gifts in memory of Richard Ettinghausen; Schimmel Foundation Inc., Ehsan Yarshater, Karekin Beshir Ltd., Margaret Mushekian, Mr. and Mrs. Edward Ablat and Mr. and Mrs. Jerome A. Straka Gifts; The Friends of the Islamic Department Fund; Gifts of Mrs. A. Lincoln Scott and George Blumenthal, Bequests of Florence L. Goldmark, Charles R. Gerth and Millie Bruhl Frederick, and funds from various donors, by exchange; Louis E. and Theresa S. Seley Purchase Fund for Islamic Art and Rogers Fund, 1982

p. 52: 13.141 John Stewart Kennedy Fund, 1913

p. 53: 1977.93 Gift of William Randolph Hearst Foundation, The Hearst Foundation Inc., 1977; 04.3.458 Rogers Fund, 1904

pp. 54, 55: 55.121.10.39 Purchase, Rogers Fund and The Kevorkian Foundation Gift, 1955

p. 57: 03.9b Rogers Fund, 1903

p. 58: 37.103 Samuel D. Lee Fund, 1937

p. 59: 30.112.46 Gift of V. Everit Macy, 1930; 63.159.4 Harris Brisbane Dick Fund, 1963

p. 60: 40.170.17 Rogers Fund, 1940

p. 61: 68.180 The Friends of the Department of Islamic Art Fund, 1968; 2003.232 Purchase, Seymour Fund, funds from various donors and Stanley Herzman Gift, 2003

p. 62: 03.9c, 03.9b Rogers Fund, 1903

p. 63: 45.106 Gift of John D. Rockefeller Jr., and Harris Brisbane Dick Fund, by exchange, 1945

p. 64: 2004.244a–d Rogers Fund, 2004

p. 65: 1982.66 Purchase, Bequest of George Blumenthal and Gift of Indjoudjian Freres, by exchange, and The Friends of the Islamic Department Fund, 1982

p. 66: 1971.234 Fletcher Fund, 1971

p. 68: 02.5.55 Gift of William B. Osgood Field, 1902

p. 69: 1978.24 Purchase, The Seley Foundation Inc. and The Louis E. and Theresa S. Seley Foundation Inc. Gifts, 1978; 14.40.612 Bequest of Benjamin Altman, 1913

p. 70: 2003.241 Louis E. and Theresa S. Seley Purchase Fund for Islamic Art and Rogers Fund, 2003

p. 71: 91.1.535a–h Edward C. Moore Collection, Bequest of Edward C. Moore, 1891

p. 72: 87.15.130 Catharine Lorillard Wolfe Collection, Bequest of Catharine Lorillard Wolfe, 1887

p. 73: 03.9c Rogers Fund, 1903

pp. 76–77: 2003.239 Purchase, Friends of Islamic Art Gifts, 2003

Islamic Art in The Metropolitan Museum of Art: A Walking Guide

Published by The Metropolitan Museum of Art, New York
In association with
Scala Arts Publishers, Inc.

Mark Polizzotti, Publisher and Editor in Chief
Gwen Roginsky, Associate Publisher and General Manager of Publications
Peter Antony, Chief Production Manager
Michael Sittenfeld, Managing Editor

Book design by Miko McGinty Inc.
Director of Publications, Scala Arts Publishers, Inc., Jennifer Norman
Edited by Jennifer Bernstein
Project Manager, Eugenia Bell
Production Manager, Christopher Zichello
Typeset in Documenta

Text, maps, and photography © 2013 The Metropolitan Museum of Art

Compilation and design © 2013 The Metropolitan Museum of Art and Scala Arts Publishers, Inc.

Cataloging-in-Publication Data is available from the Library of Congress.
ISBN: 978-1-85759-827-8

All rights reserved. No part of the contents of this book may be reproduced, stored in a retrieval system, or transmitted in any form or by any means, electronic, mechanical, photocopying, recording, or otherwise, without the written permission of The Metropolitan Museum of Art and Scala Arts Publishers, Inc.

Printed in Malaysia
10 9 8 7 6 5 4 3 2 1

Photographs of works in the Metropolitan Museum's collection are by The Photograph Studio, The Metropolitan Museum of Art.

Front cover: Mihrab (detail), Iran, 1354–55. Harris Brisbane Dick Fund, 1939 (39.20). Gallery 455 (p. 32)
Back cover: Shah Jahan on Horseback (detail), by Payag, India, ca. 1630. Purchase, Rogers Fund and The Kevorkian Foundation Gift, 1955 (55.121.10.21). Gallery 463 (p. 21)
p. 2: *Rahla*, carved by Hasan ibn Sulaiman al-Isfahani, Iran, 1360. Gallery 450 (p. 29)
p. 25: Patti Cadby Birch Court. Gallery 456 (p. 24)
p. 41: Prayer-style rug (detail), Turkey, 16th century. Gallery 460 (p. 33)
p. 73: Tile panel (detail), Iran, 17th century. Gallery 462 (p. 62)
pp. 76–77: *Book of Prayers* (*Surat Yasin* and *Surat al-Fath*), calligraphy by Ahmad Nairizi, illumination attributed to Muhammad Hadi, Iran, 1719–20. Gallery 462

The Metropolitan Museum of Art
1000 Fifth Avenue
New York, New York 10028
metmuseum.org

Scala Arts Publishers, Inc.
141 Wooster Street, Suite 4D
New York, New York 10012
www.scalapublishers.com